R. P. Phillimore's East Lothiar

Jan Bondeson

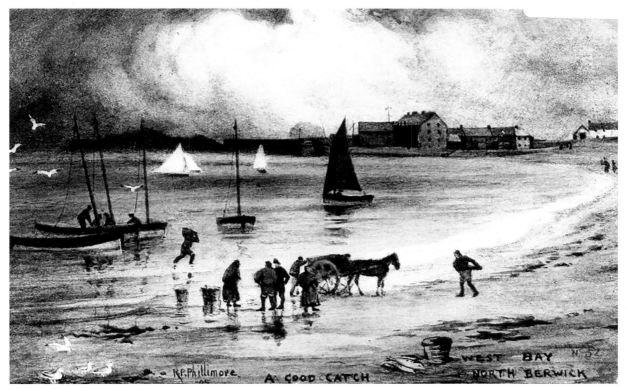

R.P.Phillimore · A GOOD CATCH · WEST BAY N° 52 NORTH BERWICK

In the 14th century the fishing village of North Berwick became a baronial burgh under William Douglas, the 1st Earl Douglas, who built Tantallon Castle in order to consolidate his power. It later became a royal burgh under James I. After the railway came in 1850, North Berwick became a fashionable seaside resort, attracting elderly people who wanted to live near the sea, Edinburgh residents who wanted to take a swim or play golf, and an incessant stream of other tourists. Other attractions were the West and East Bays, with sandy beaches perfect for bathing, on either side of the old harbour. This card shows the West Bay with some fishermen plying their trade. The harbour and some sailing vessels can be seen in the background.

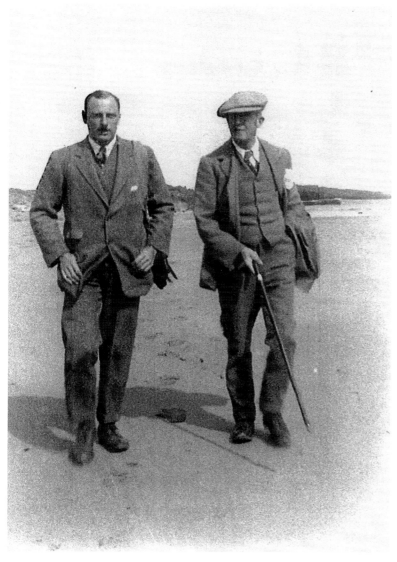

Text © Jan Bondeson, 2020.
First published in the United Kingdom, 2020,
by Stenlake Publishing Ltd.,
54-58 Mill Square,
Catrine, Ayrshire,
KA5 6RD

Telephone: 01290 551122
www.stenlake.co.uk

Printed by P2D,
1 Newlands Road,
Westoning,
MK45 5LD

ISBN 9781840338812

**The publishers regret that they cannot supply
copies of any pictures featured in this book.**

Reginald Phillimore (right) with his friend Dr. Richardson.

The Life of Reginald Phillimore

Reginald Phillimore was born in 1855, one of five children of a Nottingham doctor. A precocious youngster with a strong interest in art, he went to Oxford where he became a Bachelor of Art with a third-degree in history. Long and gruelling years as a schoolmaster followed, although he found time to publish some etchings of English cathedrals. A shy, retiring man, he began to dislike his work and the unseemly shenanigans of his boisterous pupils. Succour came in 1901, when the last of three maiden aunts, who had run a school in North Berwick, left him their house, school and money, as well as a farm and some land near Bridgnorth in Shropshire.

Now financially independent in middle age, Phillimore moved into the comfortable terraced house formerly occupied by his aunts, 'Rockstowes' at 7 Melbourne Road. Since his arrival in North Berwick coincided with the start of the Edwardian postcard boom, he decided to become a postcard artist, mainly depicting the historic buildings of Edinburgh and the quaint East Lothian countryside. From the beginning, his cards enjoyed healthy sales, since people could appreciate that they were of superior aesthetic quality. He employed a local schoolgirl, Mary Pearson, to do the delicate colouring; as she liked some variation, no two hand-coloured cards are the same.

From 1902 until 1914, Phillimore was one of Britain's postcard kingpins: his cards were bought and collected all over the country. He introduced a system of numbering his cards, although he used it in a muddled manner: often, there are both numbered and unnumbered versions of the same card, some numbers were never used, and there are several examples of two, or even three, cards sharing the same number. In total, Phillimore produced at least 643 distinctive cards, 372 of them having motifs from Scotland. Ninety-five of these cards depict various Edinburgh sights, whereas 193 are of East Lothian: he delighted in travelling around making drawings of local landmarks all over the county. The Bass Rock, which he could see from his study window at 'Rockstowes', was a perennial favourite: he more than once landed on the island in order to paint the birds there. Many of his cards are of North Berwick, and several from Dunbar, Dirleton and Gullane; in contrast, only two cards are of Haddington, and he only produced one card each of Musselburgh and Prestonpans.

The Great War came, with its depressing influence on commerce in general and the postcard industry especially suffered. In the post-war years, Phillimore's postcard empire never quite recovered, although he continued producing cards. The guidebooks he had written about the Bass Rock, Tantallon and North Berwick were regularly reprinted, and the Edinburgh art shops stocked his cards and etchings well into the 1920s. In 1936, Phillimore suffered a severe stroke with paralysis of the right side of the body and impairment of speech. Looked after by the loyal Mary Pearson, who had become his housekeeper at 'Rockstowes', he made a slow recovery, living on as an invalid until 1941. Thanks to the leading Phillimore collector Mr. Donald E. Beets, I was able to publish his full biography in my 2018 book *Phillimore's Edinburgh*, and to reproduce all his Edinburgh cards, for the first time ever. Now the time has come to display some of his superior East Lothian postcards, again with the help from Mr. Beets who has supplied many of the illustrations here.

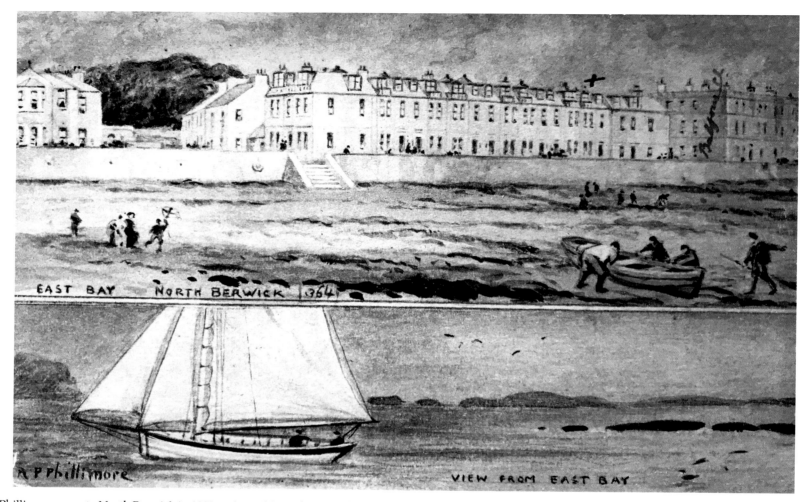

EAST BAY NORTH BERWICK 364

A P Phillimore

VIEW FROM EAST BAY

Phillimore came to North Berwick in 1902 and would stay here for the remainder of his life, at 'Rockstowes', the comfortable terraced house he had inherited from his aunts, at 7 (today 9) Melbourne Road. This road runs along the East Bay, with uninterrupted seaside views towards the Bass Rock. Including the one illustrated above, Phillimore made three postcards of the houses in Melbourne Road and its continuation Marine Parade, showing that they have changed very little since Edwardian times.

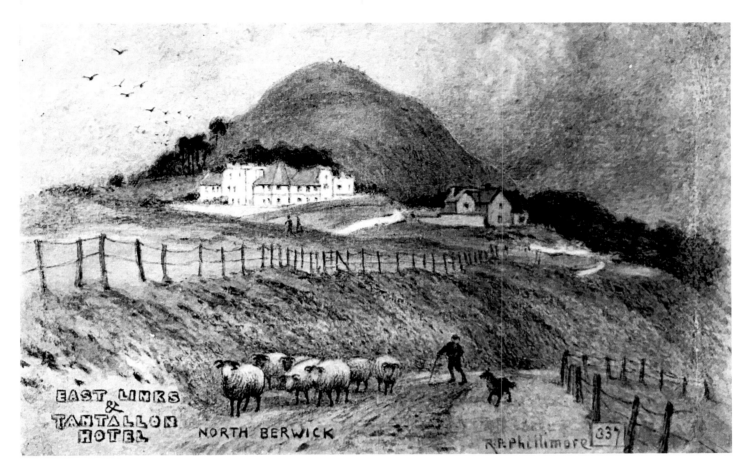

EAST LINKS & TANTALLON HOTEL

NORTH BERWICK

R.R.Phillimore 33[?]

Golf was, and still is, a popular sport in North Berwick. In 1905, due to the overcrowding of the West Links Golf Course, it was decided to construct another one, the Glen Golf Course at East Links, which is still operational. The Tantallon Hotel, overlooking the golf course, was constructed in 1908. It was used to billet soldiers in the First World War and afterwards as a St. Dunstan's Home for blind veterans. It no longer stands. In the background of Phillimore's card is the Law, a high conical volcanic hill, on the summit of which are ruins of some military buildings dating back from when the Law was used by lookouts. It offers splendid views of the Firth of Forth and the Bass Rock. Since 1709, the summit of the Law has been adorned by a whalebone arch, the bones being replaced three times until finally removed in 2005. In 2008, an anonymous donor paid for a replica whalebone arch to be airlifted to the summit, in order to give North Berwick back one of its landmarks.

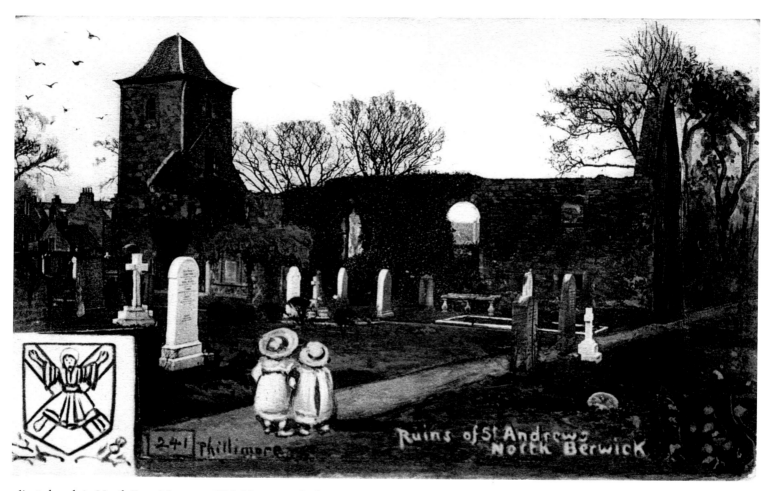

The earliest church in North Berwick was at Kirk Ness near the harbour; it was in use from the 12th century until 1652. The ruins can still be seen. A new St. Andrew's Church was built at Kirk Ports: it was mostly completed in 1718, and a tower was added in 1771. In 1820, a vestry was added, as were two large new windows. The church remained in use until 1883, at which time the growing population of North Berwick needed a larger church. St. Andrew's was demolished and the lead, slates, woodwork and floor sold at auction. The walls of the deserted church were allowed to stand as a picturesque ruin, as shown in the postcard as they still do so today attracting regular visitors.

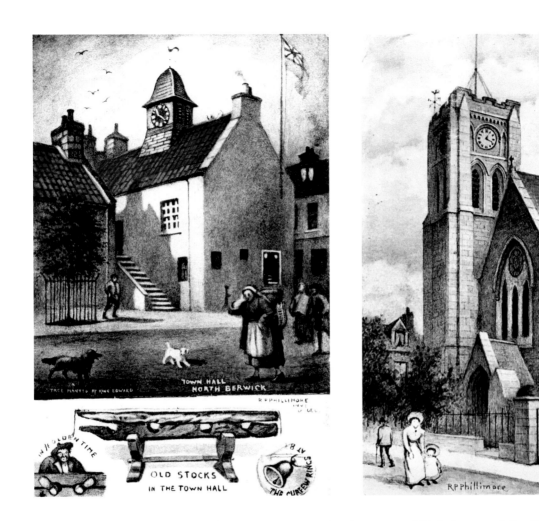

North Berwick's town hall, dating back to the 17th century, is situated at the corner of High Street and Quality Street. An outdoor stair leads up to the council chamber, underneath which are two shops, one of which formerly the prison. The stocks were kept for many years in the town hall. Today they are in the Coastal Communities Museum on School Road. The small tree on the left is still there, but having grown considerably, today obscures the town hall itself. Further down the High Street is the church of St. Andrew Blackadder, which looks entirely unchanged since Phillimore's time.

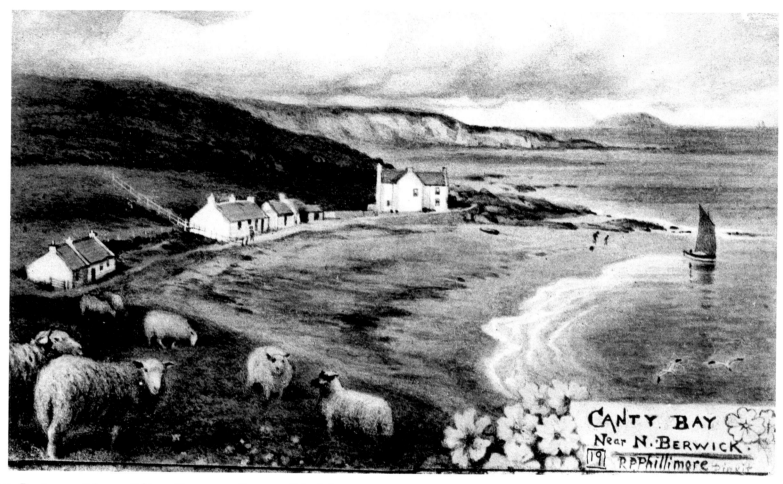

Canty Bay is a small former fishing village two miles east of North Berwick. Known for its beautiful and unspoilt countryside, sandy beaches and proximity to Tantallon, it was popular with tourists and people wanting to play golf on the links nearby. Phillimore was fond of taking a stroll to Canty Bay, to admire the unspoilt scenery and make a sketch or two. The steam launch *Bonnie Doon* (shown on the postcard on the next page) took the more adventurous tourists out to the Bass Rock from Canty Bay. The water off East Lothian is remarkably clear and free from pollution, rendering the area of Canty Bay a haven for wildlife. Once when I was driving a boat towards the Bass Rock, a pod of dolphins swam along on either side of the vessel, so close that they could almost be touched.

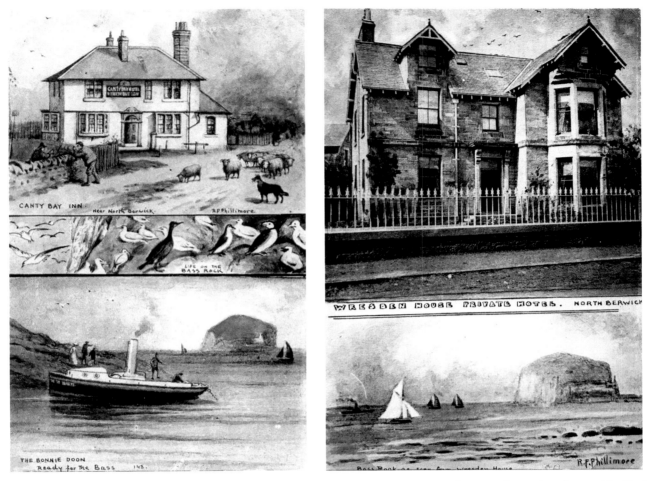

The Canty Bay Inn was popular with tourists, golfers, nature enthusiasts, and people coming to North Berwick to enjoy the seaside. Dating from around 1900 as a hotel, the building still trades, as a superior bed and breakfast establishment. Wresden House, the home of the former North Berwick school left to Phillimore by his maiden aunts, was let as a private hotel at the time he immortalised it in one of his postcards, although he eventually sold the building. This substantial property still stands today, at 2 York Road, looking well-nigh unchanged since Phillimore's time, although it has been subdivided into flats. There are views towards the Bass Rock from the upper windows, hence the second image on the postcard.

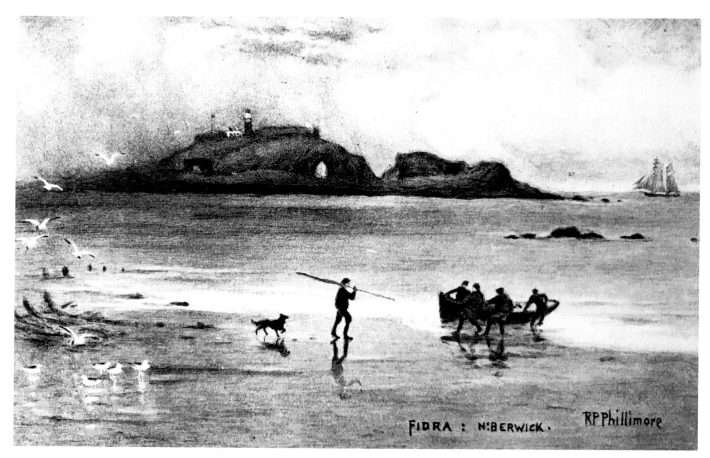

FIDRA : N:BERWICK. RP Phillimore

Fidra is a volcanic rock like most of the islands near North Berwick. It consists of three parts: a crag at one end with a lighthouse, a low isthmus in the middle, and a rocky stack at the other end. Fidra was inhabited from early times and there are ruins of an ancient chapel dedicated to St. Nicholas in 1165. The powerful de Vaux family, of Dirleton Castle, built a small castle on the island, but in 1220 William de Vaux gifted Fidra to the monks of Dryburgh Abbey. A lighthouse was constructed on the island in 1885; by this time, its keepers were the only human beings permanently residing on this rocky isle. Fidra has long been home to a healthy population of puffins, although the introduction of the tree mallow plant by lighthouse keepers annoyed the birds since it obscured their burrows; a troop of RSPB Scotland volunteers came to the rescue and cleared the unwanted plants, meaning that puffin numbers on Fidra are once more on the rise.

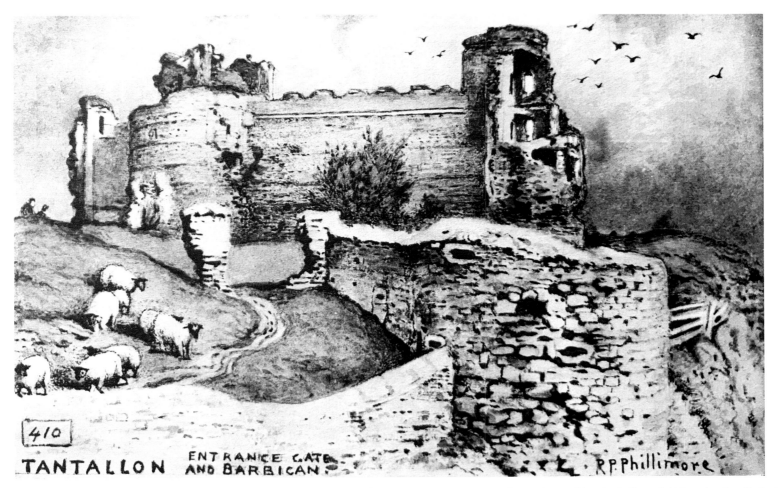

TANTALLON ENTRANCE GATE AND BARBICAN. R.P.Phillimore

410

The most formidable castle ruin of East Lothian, Tantallon dates back to the 1350s. For many years, it was owned by the influential Douglas family, before James IV made sure it passed into Crown hands in 1529. The great outer gate of Tantallon was once secured with massive double doors, and a tower was added in the 1520s to strengthen the castle entrance. The entrance gate and barbican have not changed since Phillimore's time, except that there are no longer any sheep on the premises. The present ruinous state of Tantallon is due to Oliver Cromwell, who ordered his henchman General Monck to destroy the castle in 1651, something that was accomplished according to orders.

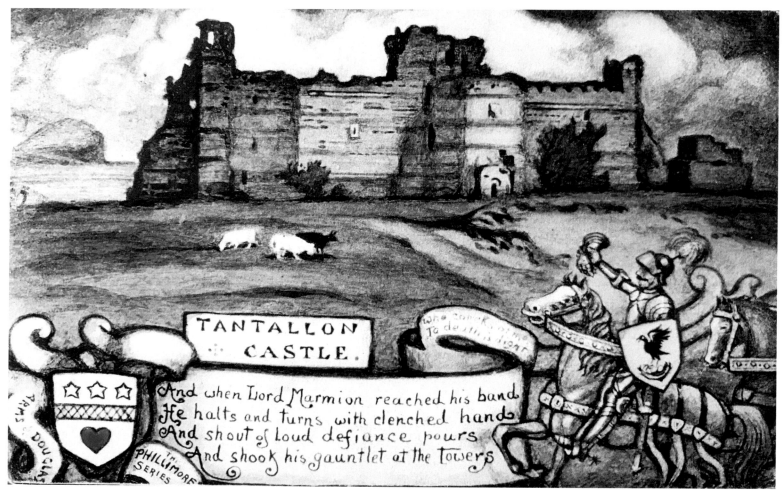

TANTALLON
CASTLE.

And when Lord Marmion reached his band
He halts and turns with clenched hand,
And shout of loud defiance pours,
And shook his gauntlet at the towers

THE
PHILLIMORE
SERIES

After General Monck had done his worst in 1651, Tantallon was reduced to a picturesque ruin, inspiring artists like Alexander Nasmyth and authors like Robert Louis Stevenson. In Sir Walter Scott's long poem *Marmion*, the eponymous anti-hero, a scheming favourite at the court of Henry VIII, quarrels with the Earl of Angus when visiting Tantallon, and calls him a liar. The outraged Earl orders his henchmen to seize Lord Marmion, but the nobleman makes a speedy escape under the heavy portcullis, before joining his own men and shouting a defiant oath in the direction of the mighty castle.

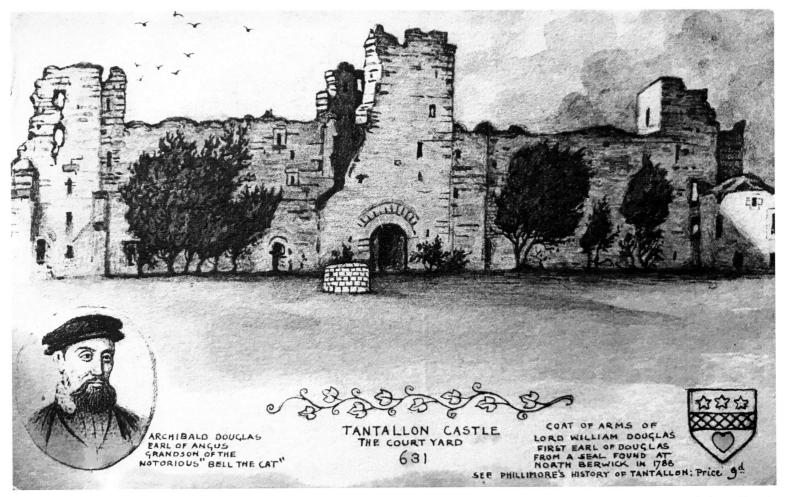

ARCHIBALD DOUGLAS
EARL OF ANGUS
GRANDSON OF THE
NOTORIOUS "BELL THE CAT"

TANTALLON CASTLE
THE COURTYARD
631

COAT OF ARMS OF
LORD WILLIAM DOUGLAS
FIRST EARL OF DOUGLAS
FROM A SEAL FOUND AT
NORTH BERWICK IN 1788
SEE PHILLIMORE'S HISTORY OF TANTALLON: Price 9d

The great courtyard at Tantallon comprised storage buildings and workshops during the castle's heyday, but these are all gone, along with the wall enclosing the courtyard towards the sea. The remains of a sea-gate show that the castle could be accessed and supplied by boat. The well seen in Phillimore's drawing still exists: it is 32 metres deep and used to be the castle's main water supply. There are no longer any trees growing inside the courtyard.

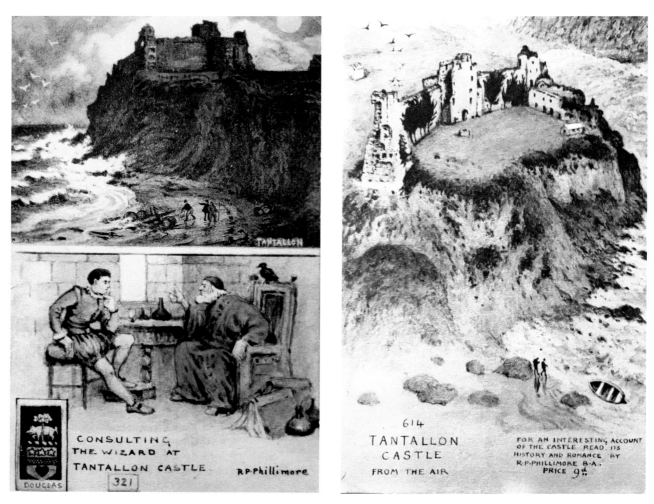

CONSULTING THE WIZARD AT TANTALLON CASTLE

R.P. Phillimore

DOUGLAS

321

614

TANTALLON CASTLE

FROM THE AIR

FOR AN INTERESTING ACCOUNT OF THE CASTLE READ ITS HISTORY AND ROMANCE BY R.P. PHILLIMORE B.A. PRICE 9d.

It is not generally known that Phillimore was a novelist: under the pen name 'Robert Bridgnorth' he wrote *The Wizard of Tantallon* and published it himself. It was an old-fashioned, insipid novel and nobody bought it; copies are extremely scarce today, although a few libraries have the book. In real life, there never was any wizard in residence at Tantallon. Phillimore had an interest in aeronautics, and some person must have given him a ride in an aeroplane, for him to depict Tantallon from the air.

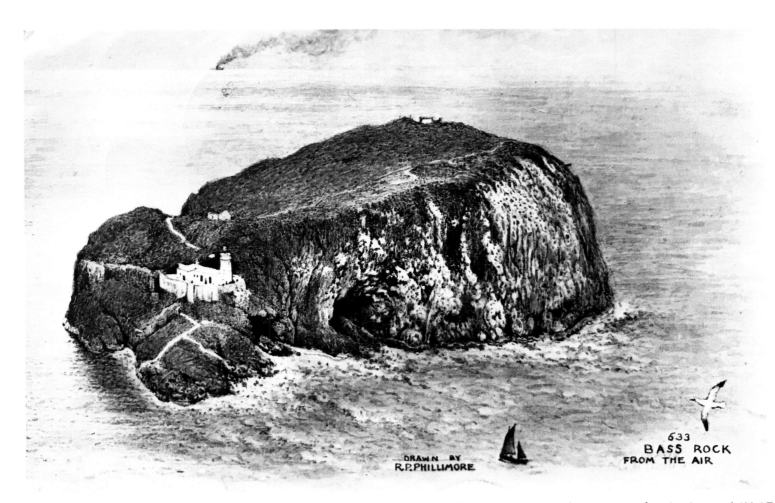

DRAWN BY
R.P.PHILLIMORE

633
BASS ROCK
FROM THE AIR

The history of the Bass Rock goes far back into time. Baldred, the East Lothian saint, is said to have founded a hermitage on the island around 600 AD, and the ruins of St. Baldred's Chapel still stand. The Bass Rock passed eventually into the ownership of the Lauder family, who built a castle on the island and kept sheep. King James I used the Bass to imprison his cousin's son, Walter Stewart, under the charge of Sir Robert Lauder. In 1497, King James IV visited the Bass as a guest of Sir Robert Lauder, staying in his castle. James VI also came to the Bass in 1581, as a guest of a later Lauder, and liked the island so much that he offered to purchase it, but was refused.

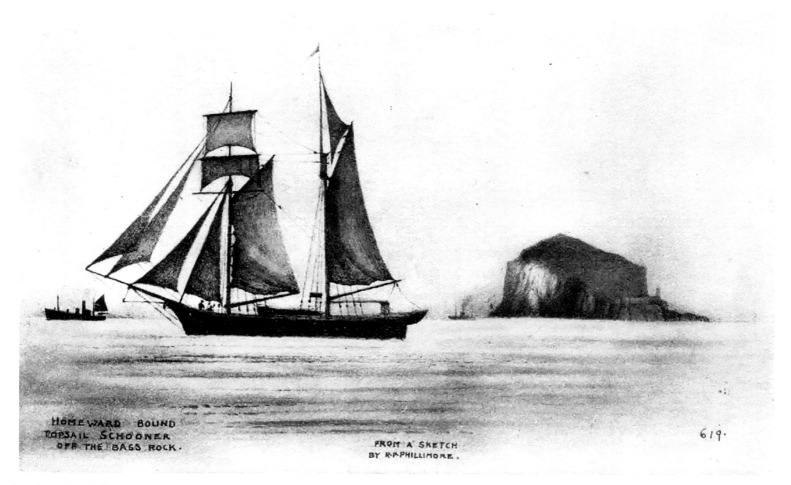

HOMEWARD BOUND
TOPSAIL SCHOONER
OFF THE BASS ROCK.

FROM A SKETCH
BY R.P.PHILLIMORE.

619.

During the reign of Charles II, the Bass became a notorious prison, mainly used for the Covenanters. Thirty-nine of them were held on the island, under appalling conditions: there was a well that produced fresh water, but fresh meat was a scarcity and the fishy taste of the seabirds was a torment to the wretched prisoners. In 1691, four Jacobite officers were imprisoned on the Bass, but they successfully took over control of the island and ordered the garrison to depart. After reinforcements arrived, they withstood a siege of nearly three years, under trying conditions, before they surrendered with full military honours in May 1694. The Bass later passed into the ownership of the Dalrymple family, to whom it belongs today.

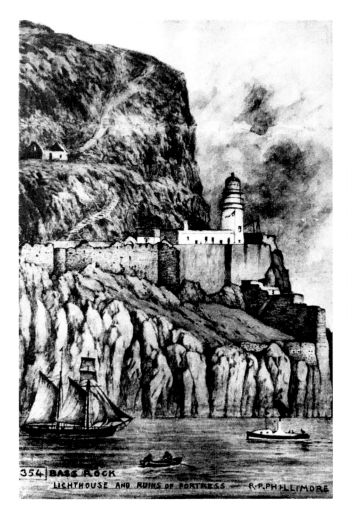

354 BASS ROCK
LIGHTHOUSE AND RUINS OF FORTRESS — R.P.PHILLIMORE

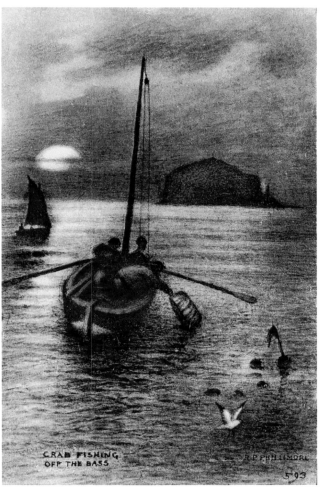

CRAB FISHING
OFF THE BASS

R.P.PHILLIMORE

5-03

The Bass Rock lighthouse was constructed in 1902 by the celebrated engineer David Stevenson, a cousin of Robert Louis. He quarried stone from the old castle to build the 20-metre high lighthouse, which served its purpose well for many years thereafter. It was lit with gas derived from vaporised paraffin oil, monitored by the lighthouse keeper. In 1988 the lighthouse was converted to electricity and remote control; the lighthouse keeper was no longer needed, and the Bass Rock now is without any permanent human resident.

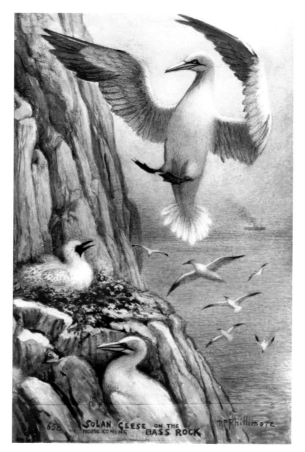

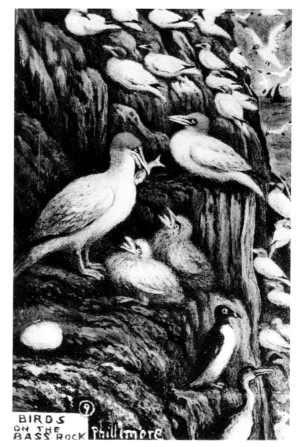

The Bass Rock is home to the largest gannet colony in the world: 150, 000 birds spend their summer residence here, having been in Africa for the winter. The gannet, or 'solan goose' as it was known in Phillimore's time, is a large and formidable-looking seabird, with a white body, a yellow neck and head, and black and white speckled wings and tail. The reason that much of the Bass Rock appears white from a distance is the sheer number of birds, and their acrid droppings. The gannet hunts fish by diving headlong into the sea, as any visitor to the Bass Rock can observe at close range. The air is full of birds, which are squawking cacophonously, and the smell from their droppings is very noticeable. Phillimore drew some beautiful postcards featuring the Bass Rock gannets; he is likely to have travelled to the island from Canty Bay or on a vessel from North Berwick, but today access to the island is controlled by the Scottish Seabird Centre.

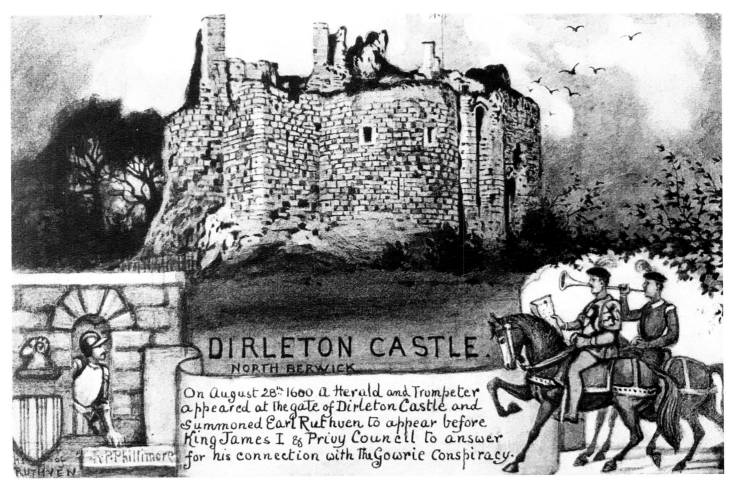

DIRLETON CASTLE.
NORTH BERWICK

On August 28th 1600 a Herald and Trumpeter appeared at the gate of Dirleton Castle and summoned Earl Ruthven to appear before King James I & Privy Council to answer for his connection with The Gowrie Conspiracy.

This castle was first constructed by the wealthy Anglo-Norman family of de Vaux, on a craggy knoll that dominated the lands of their barony, close to the road westwards from North Berwick. When Edward I invaded Scotland, he sent a force under Anthony de Beck, the Palatine Bishop of Durham, to besiege Dirleton Castle. John de Vaux defended his castle with vigour, but when the English brought some powerful siege engines, he had to give up. The castle remained in English hands until 1311. During the reign of David II, the castle passed into the family of Halyburton, after one of them had married a de Vaux heiress. The Halyburtons had plenty of money and did much to improve Dirleton Castle. James IV visited the castle in 1505.

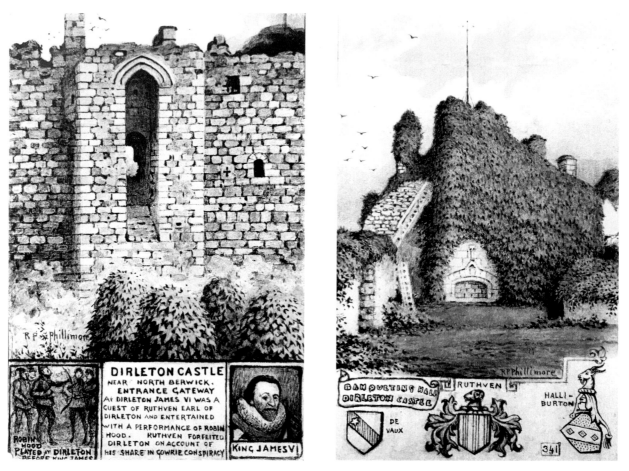

In 1515, after a Halyburton heiress had married William Lord Ruthven, the castle passed into his family. Patrick Lord Ruthven, their son and heir, was one of the main actors in the murder of Rizzio at Holyrood. Another Ruthven, the Earl of Gowrie, kidnapped James VI during his minority and held him captive at his castle near Perth; for his various misdeeds, he was beheaded in 1585. In 1600, the brothers John Earl of Gowrie and Alexander Ruthven were murdered at Perth, allegedly for conspiring to have James VI murdered. For their part in the 'Gowrie Conspiracy', the Ruthvens lost Dirleton, for good. The architect of the downfall of Dirleton Castle was Oliver Cromwell, who dispatched Generals Monck and Lambert, with numerous troops and plenty of artillery, to capture and demolish the once-proud old castle.

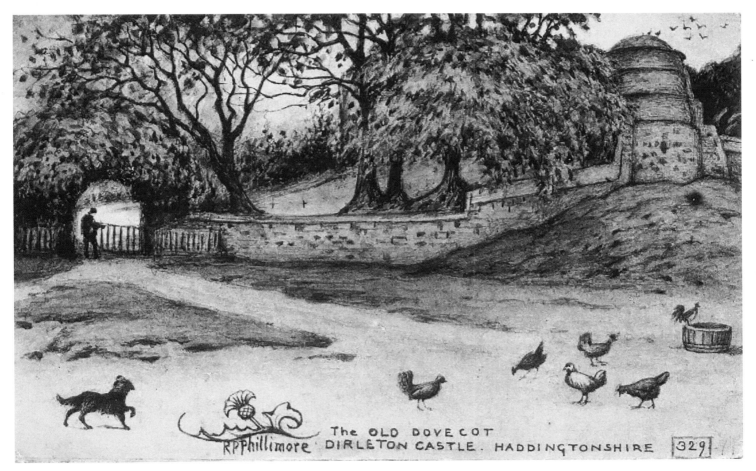

The OLD DOVECOT
DIRLETON CASTLE. HADDINGTONSHIRE
RP Phillimore
329

Dirleton Castle was abandoned in 1663 by its new owners, the Nisbet family, who continued to maintain the gardens. It was a picturesque, ivy-clad ruin when Phillimore came to call in Edwardian times. Since then, the castle has passed into state care: it is managed by Historic Environment Scotland, and is a popular tourist attraction, not least thanks to its well-kept gardens. One of the buildings open to visitors is the 16th century dovecot, which once held boxes for 2,000 pigeons. The birds nested in these boxes, flying in and out through a central hole in the roof. They were regularly harvested for food: during a banquet, hundreds of 'squabs' (young pigeons) might be consumed by the hungry guests. The dovecot is surprisingly intact today, and ready for the occupation of the feathered tribe, having survived the onslaught of the marauding troops of Oliver Cromwell.

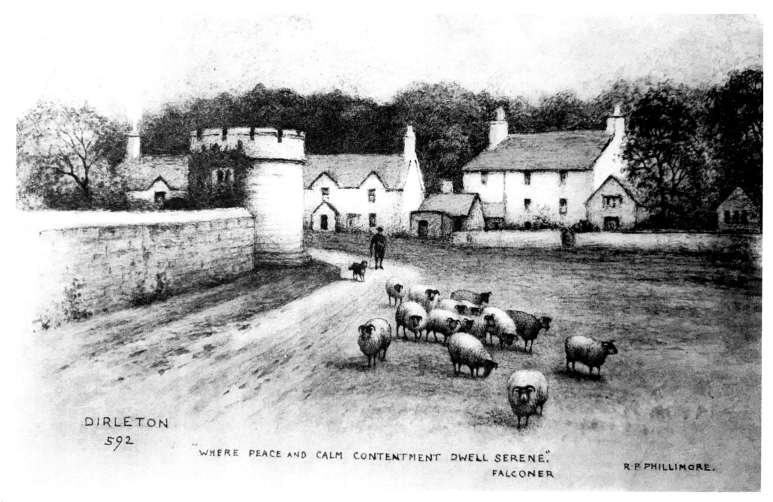

DIRLETON
592

"WHERE PEACE AND CALM CONTENTMENT DWELL SERENE."
FALCONER

R·P·PHILLIMORE.

In this rural view, we see the main road through Dirleton, with one of the castle's low towers to the left; a shepherd is driving a flock of sheep through the village, with his sheepdog. Dirleton is remarkably intact today and has not changed much since Phillimore's time: he would have recognised many of the buildings, although the main road through the village has been widened and the omnipresent motor cars have infested even this East Lothian idyll. The house just to the right of the tower was an inn in Phillimore's time; it is the Castle Inn today.

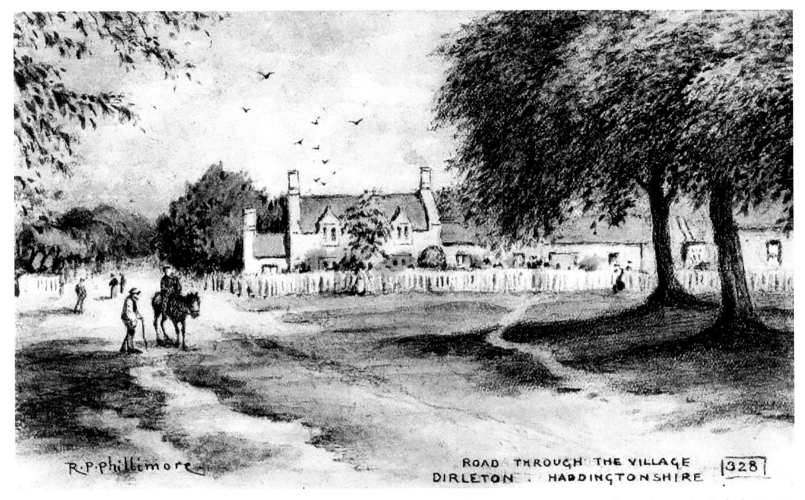

R.P.Phillimore

ROAD THROUGH THE VILLAGE
DIRLETON : HADDINGTONSHIRE [328]

The oldest houses in Dirleton are either on the main road through the village, or flanking the extensive village green, the southern side of which is bordered by the walled grounds and gardens of the castle. To the west are the castle and the houses seen in the previous postcard. Looking to the east, having just passed the castle dovecot, Phillimore would see these three old houses, still there today. The largest of them is Vine Cottage, a well looked-after old house with meticulously tended gardens.

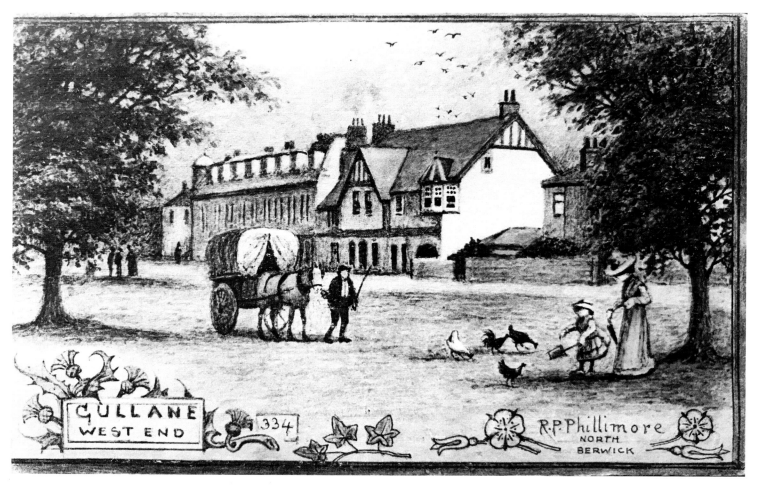

GULLANE
WEST END

334

R.P.Phillimore
NORTH
BERWICK

Gullane, a prosperous seaside town west of North Berwick, has long attracted well-to-do pensioners and golfing enthusiasts of all ages, but also people 'priced out' of expensive Edinburgh. Although Gullane no longer has a railway station, there are frequent bus services to the capital. The West End of town, depicted by Phillimore in Edwardian times, has hardly changed at all, although there are no longer any horse-driven carts or hens out in the road. The house on the right is 'The Saughs' and still a private house; the large mock-Tudor house to the left of it is today the 'Main Course' Italian restaurant; the terrace leading to the left is home to a coffee house, an antiques shop and a pharmacy.

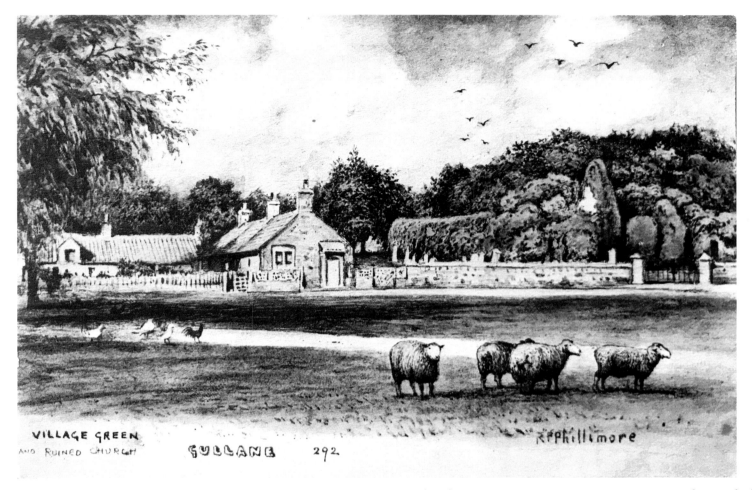

VILLAGE GREEN
AND RUINED CHURCH GULLANE 292

R.P.Phillimore

Gullane is recorded to have had a church as early as the 9th century. St. Andrew's Church dates from in 1170 and remained in use as the parish church until it was 'overblawn with sand' and abandoned in 1612. Although the ruins remain near the village green, the buildings to the left of it in Phillimore's card have been much altered and today constitute offices for the nearby golf course. The church ruins are open to visitors and well worth a visit: the roofless nave can still be entered, although the chancel was converted into a burial aisle for the Yule family in 1827. Many gravestones remain: some of them ancient and weatherbeaten, others Victorian and still fully legible.

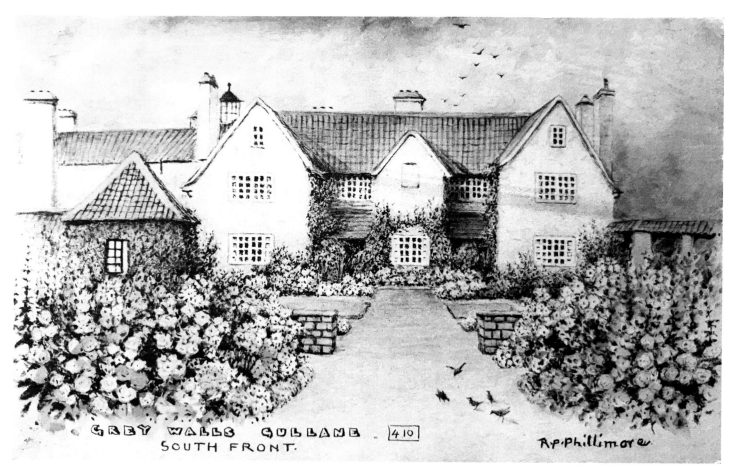

GREY WALLS GULLANE. 410
SOUTH FRONT.

R.P.Phillimore

This large and imposing house was built in 1901 as the Gullane residence of the Hon. Alfred Lyttelton MP, to designs by Sir Edwin Lutyens. In 1905, Grey Walls was sold to the American railroad magnate William Dodge James and his Scottish wife Evelyn, who added to the house and once entertained Edward VII there. The Jameses were in residence when Phillimore came to call a few years later; he was so impressed with this large and luxurious house and its beautiful gardens that it inspired two of his postcards. In 1924, Grey Walls was purchased by Sir James Horlick (son of the co-founder of the malted drink business), who did not live there permanently; after the war, his daughter Ursula inherited the house and developed it into a hotel. It is still standing today as the Greywalls Hotel, looking well looked after.

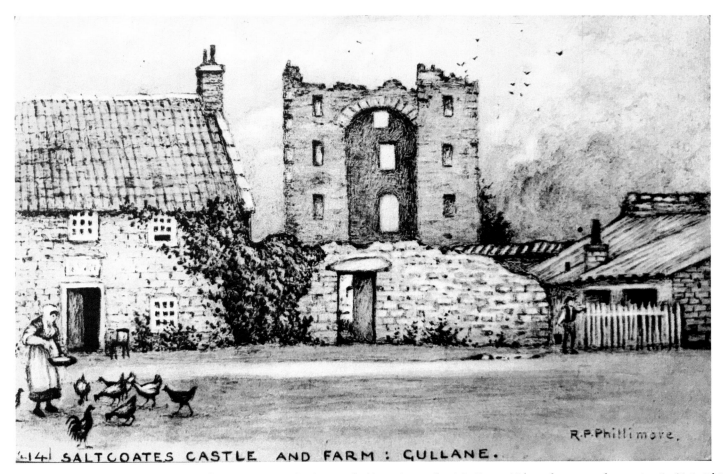

414 SALTCOATES CASTLE AND FARM : GULLANE.

R.P.Phillimore.

The ruins of Saltcoates Castle can be seen near the tiny village of Saltcoats, half a mile south of Gullane. Although not much remained of it in Phillimore's time, this was once a castle of some importance. Built in the 16th century, it belonged to the Livingstone family for many years. It was of uncommon construction in that it had a courtyard surrounded by tall buildings, with a fortified tower on one side. In the 18th century, the castle passed into the Hamilton family of Pencaitland; it was occupied until after 1800, but partly demolished in 1820. Since the sturdy tower could not be knocked down, it has remained standing, albeit in a ruinous condition.

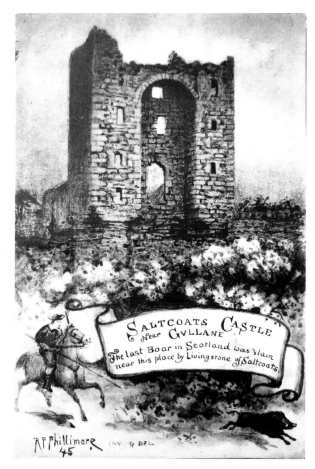

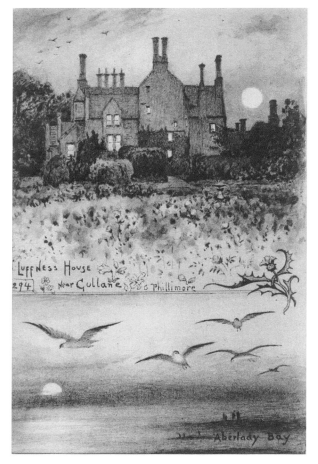

There is consensus that the wild boar was wiped out in Scotland in the 17th century, but divergent opinions exist as to where the last one was killed. Phillimore had heard the version that it was hunted down by Livingstone of Saltcoates not far from his castle, and he amusingly depicts the last wild boar running for its life, with a spear-wielding huntsman in hot pursuit on horseback. Conflicting legends state that it was killed at Prora, East Lothian, at Swinton, Berwickshire, or at Torinturk, Argyll (near Tarbert). Luffness House near Aberlady is a castle of 13th century origins, probably designed to control landings in Aberlady Bay. It was long in the family of the Earls and Dunbar and March. In 1739, the reconstructed castle was sold to the Earl of Hopetoun, and it is still held by the Hope family. A large and imposing building, it is not open to the public, although it can be seen from the road.

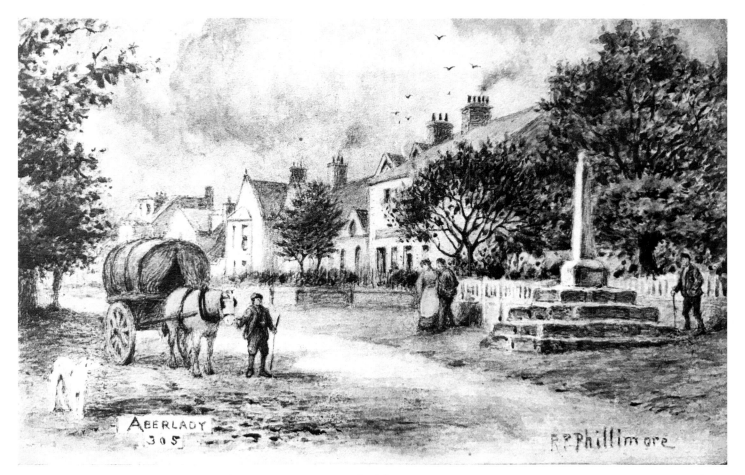

ABERLADY
305

RPPhillimore

Continuing westwards from Gullane, we come to the village of Aberlady, which has ancient roots as a centre for pilgrims travelling between the monasteries of Iona and Lindisfarne. From Medieval times until the 17th century, it was the port for nearby Haddington, with much fishing, sealing and whaling going on. In Phillimore's time, Aberlady was a quiet and sleepy village: in his postcard, we see a horse-drawn cart passing the Mercat Cross, with the tiny and ancient Cross Cottage behind it. The Mercat Cross's still a feature, although much of the rural feel to the main street through the village has gone due to the traffic.

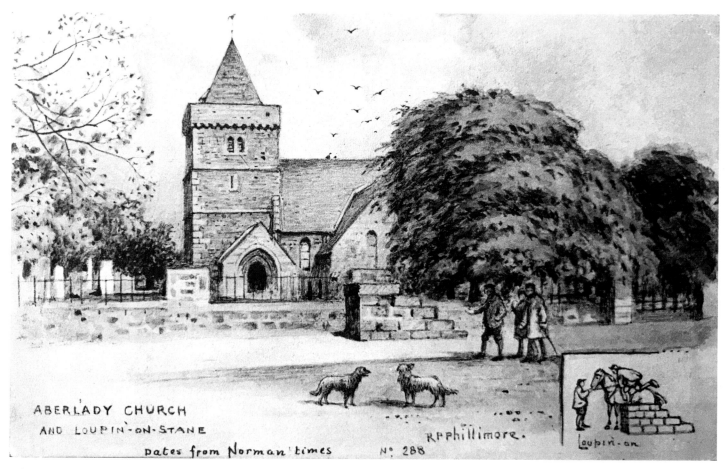

ABERLADY CHURCH
AND LOUPIN'-ON-STANE
Dates from Norman times
R.P.Phillimore.
Nº 288
Loupin-on

Aberlady Church began its existence as a 15th century watch tower; a small church was added in 1509, serving the parish until it was enlarged in 1773. The present church dates back to 1887, when it was felicitously rebuilt by the London architect William Young, at orders of the Earl of Wemyss, who also sponsored some fine stained-glass windows. Inside the church is a 1762 marble monument to Lady Elibank, attributed to Canova, and a life-sized effigy of Louisa Bingham, Countess of Wemyss and March. Outside the church, there is a Louping-on Stane for visitors arriving by horse or carriage. Similar mounting blocks have survived in Duddingston and in East Kilbride.

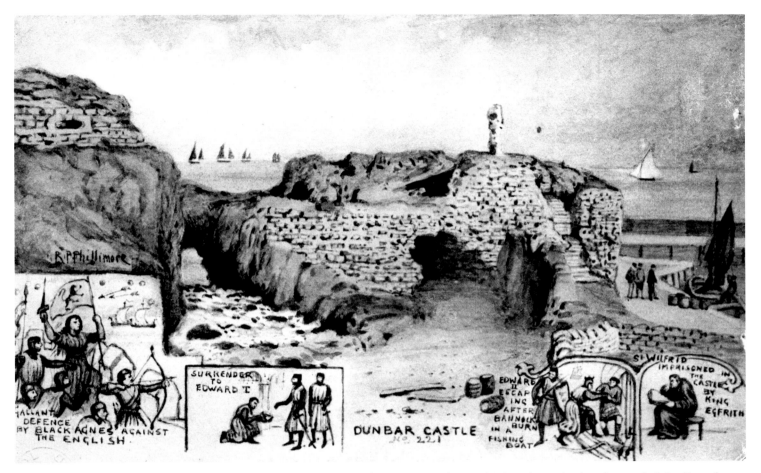

There has been a castle overlooking Dunbar Harbour since early Medieval times, several times besieged, repaired and extended. Its finest hour came in 1338, when 'Black Agnes' the Countess of Dunbar and a small troop of soldiers successfully withstood a siege from superior English forces. In 1566, after the murder of Rizzio, the Earls of Bothwell and Huntly rescued Mary and Darnley from Holyrood, and took them to Dunbar Castle, where they recruited soldiers and gathered supplies before entering Edinburgh in triumph. But Mary was dethroned and Bothwell exiled, by orders from the Scottish Parliament, Dunbar Castle was besieged and Bothwell's remaining henchmen captured, before the castle was razed to the ground. Phillimore's postcard shows the very ruinous state of this once-proud castle, the remains of which are today home to a quantity of seabirds.

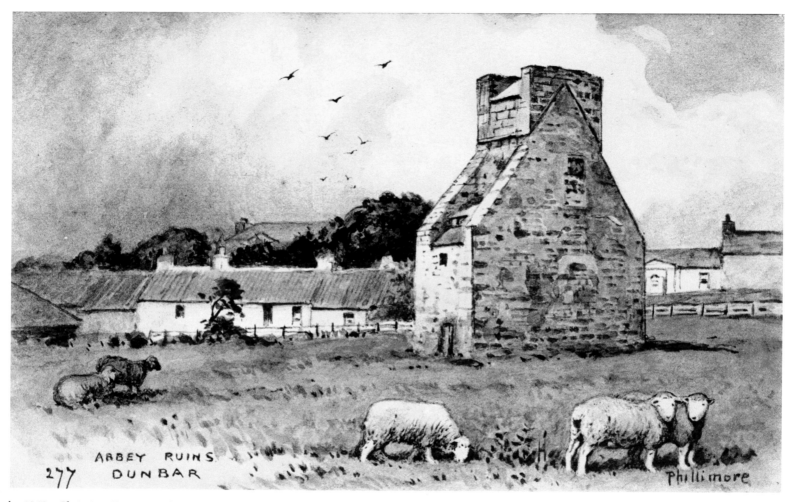

ABBEY RUINS
DUNBAR

277

Phillimore

In the 1240s, Christina Countess of Dunbar founded a small house of Trinitarian or Red Friars in Dunbar. The friars flourished for centuries, having a friary to live in as well as a church and a graveyard, but the Abbey was dissolved prior to 1529. In 1830, the tower of the church was still standing, although it had been converted into a dovecot. It was still there, in a field called Friar's Croft, when Phillimore came to call in Edwardian times. The Abbey ruins reamin, near the Co-Op supermarket; the cottages seen in the background have also survived. I can see the Abbey ruins from my garden at the Priory in Dunbar.

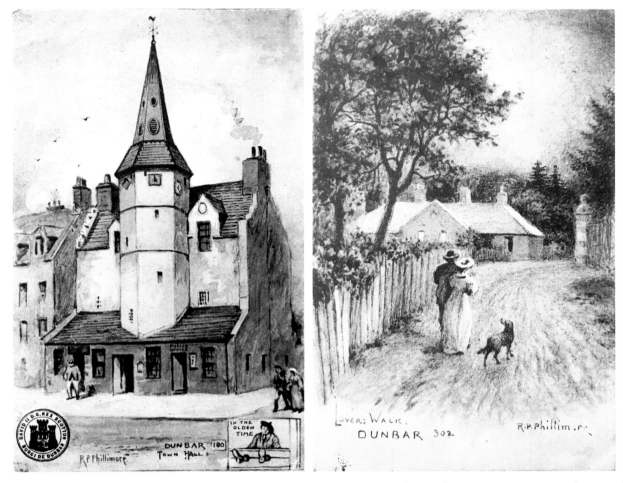

Dunbar Town Hall dates back to the late 16th century. Inside the tower is a spiral staircase leading to the second-floor council chamber through an ancient door. On the first floor is a prison cell, complete with the original window bars and door, and another room that was once a debtor's prison cell. Since Phillimore's time, the ground-floor luckenbooths, one of them housing the police office, have been demolished, and the town hall has been extended to the side, in order to house a museum and offices. Dunbar's Lovers' Walk, traditionally used by courting couples, began at the Bleachfield and proceeded to Lochend Wood via a railway tunnel. A part of it is still in existence, leading south at the end of Kellie Road.

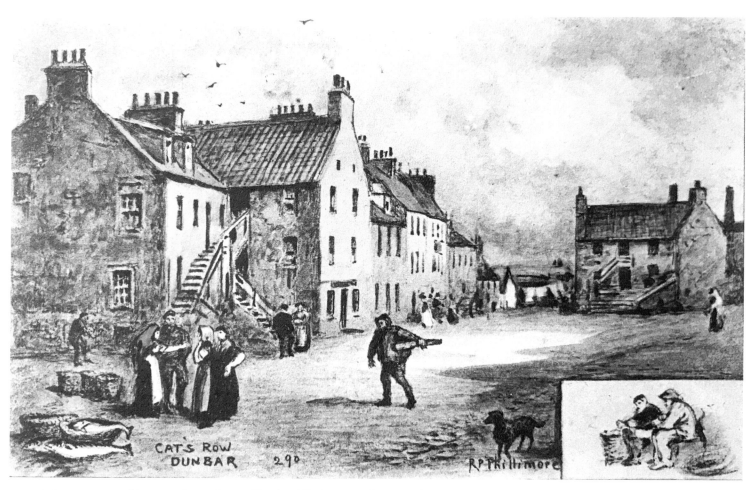

CAT'S ROW
DUNBAR 290

RP Phillimore

This was an infamous row of houses situated near Dunbar Harbour, at the cross between Victoria Street and Castle Gate. In Edwardian times, this fisherman's slum was considered picturesque, and more than once depicted in the picture postcards of the time. Its name is said to have been derived from the multitude of cats infesting the neighbourhood, although Phillimore has instead included a dog and some recently caught codfish on his postcard. Cat's Row was demolished in 1935, and a row of more salubrious cottages replace it in what is now Victoria Street.

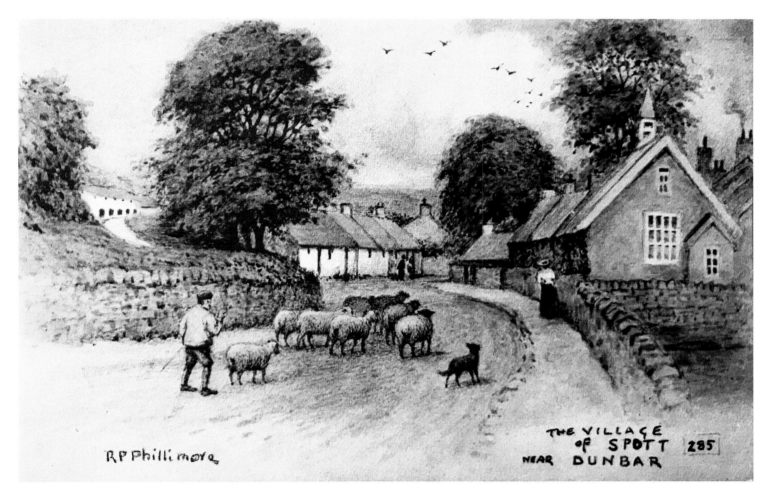

RP Phillimore

THE VILLAGE OF SPOTT 285 NEAR DUNBAR

The small village of Spott, situated two miles south-west of Dunbar, is quite ancient and a centre during the Roman occupation of southern Scotland. In 1570, the Parson of Spott, John Kelloe, murdered his wife and hanged her in the manse, before going to church and delivering "a more than usually eloquent sermon." He was executed in Edinburgh for his crime. The church is an old and venerable building, but has been restored over the centuries; the old manse that was home to John Kelloe has been pulled down and replaced. The house depicted by Phillimore, the village hall with its characteristic steeple, survives in a good state of repair.

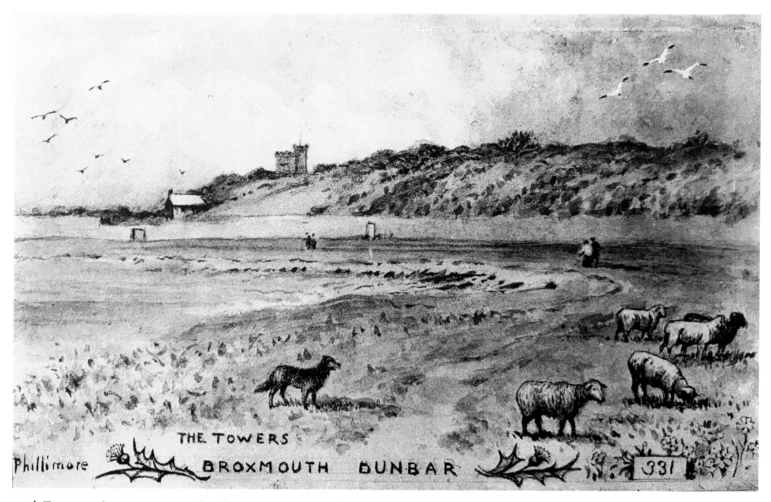

THE TOWERS
BROXMOUTH DUNBAR
Phillimore
331

Broxmouth Towers, today more commonly referred to as Broxmouth Park Observatory or the Sloe Bigging Outlook Tower, was constructed around 1850 for the Duke of Roxburgh, as a folly enjoying outstanding sea views. It has a single octagonal room and a two-storey tower. Phillimore depicts it as seen from the coastline, with some couples taking exercise on the coastal path, and a dog and some sheep in the foreground. Today, the towers are a far from prepossessing sight, very much ruined and open to the elements, and situated in the middle of a caravan park.

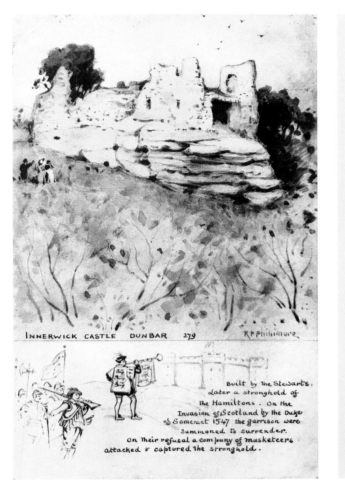

INNERWICK CASTLE DUNBAR 279 R.P.Phillimore

Built by the Stewarts.
Later a stronghold of
the Hamiltons. On the
Invasion of Scotland by the Duke
of Somerset 1547 the garrison were
summoned to surrender.
On their refusal a company of musketeers
attacked & captured the stronghold.

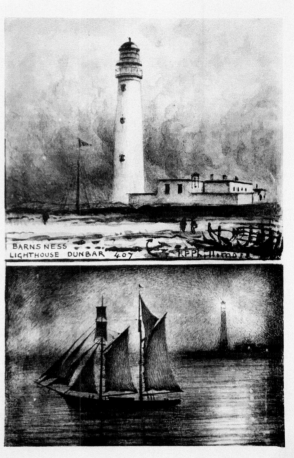

BARNS NESS
LIGHTHOUSE DUNBAR 407 R.P.Phillimore

Innerwick Castle originated in the 14th century and served as a stronghold, until destroyed by English forces under the Duke of Somerset in 1547. A picturesque ruin in Phillimore's time, the old castle is much overgrown and neglected today. It can be reached with difficulty by a woodland walk from the village of Crowhill. Barns Ness Lighthouse was erected between 1899 and 1901, first being illuminated in October 1901. It was manned by two lighthouse-keepers until 1966 when it was electrified; in 1986, it was completely automated. It was deactivated in 2005 as it was no longer needed. The buildings adjacent to the lighthouse are today holiday cottages.

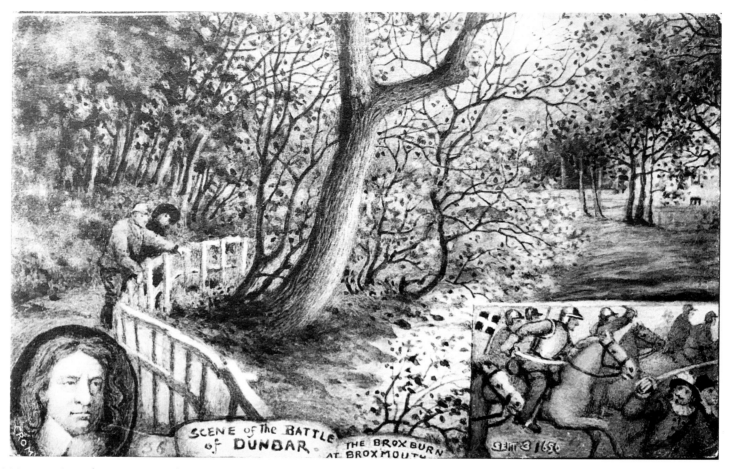

SCENE OF THE BATTLE of DUNBAR. THE BROXBURN AT BROXMOUTH. Sept 3 1650

While visiting Dunbar, Phillimore took the opportunity to see the battlefield where Oliver Cromwell's Parliamentarian army had defeated the Royalist Scots on 3rd September 1650. The invading English army was ravaged by disease, so withdrew towards Dunbar, where supplies were received at the harbour. A large Scottish army commanded by David Leslie pursued them and took up a strategic position on the hills south of Dunbar. Unwisely, they surrendered this position, advancing towards Spott, where Cromwell attacked them with great ferocity, exposing the right flank and unleashing a powerful cavalry charge. The Scots fled, many of them being taken prisoner and led south under miserable conditions, leaving the road to Edinburgh open to Cromwell.

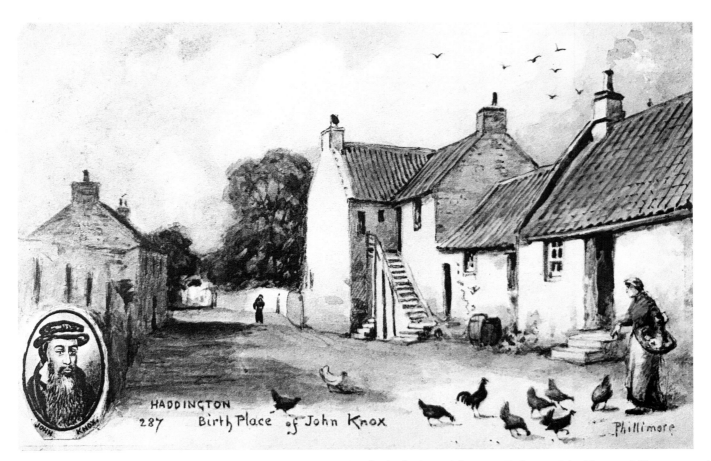

HADDINGTON
287 Birth Place of John Knox

One of Haddington's claims to fame is that the town is in contention for being the birthplace of the great Reformer John Knox, said by many to have been born in the Giffordgate area in or around 1513. According to a paper by the local historian J.H. Jamieson, the house in the Giffordgate pointed out as Knox's birthplace was demolished prior to 1837. In 1881, none less than Thomas Carlyle made sure that an oak was planted and a memorial stone erected on the site; this oak is today quite a majestic tree. It is a mysterious matter that there was a 'John Knox's House' in Haddington in Edwardian times, the subject of more than one postcard including that of Phillimore. The truth appears to be, according to the Jamieson article, that another house in the Giffordgate was pointed out to the tourists as the birthplace of John Knox, although it only dated back to the 18th century; this building was still standing as recently as the 1930s, but does not remain today.

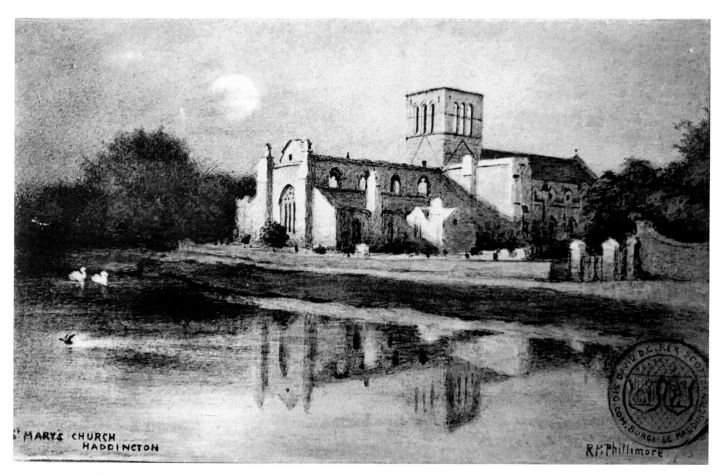

St. Mary's Church in Haddington was completed in 1486, standing near the Tyne on the site of an earlier church. During the English occupation of Haddington in 1548, the church was badly destroyed. The townspeople rebuilt the nave and used it for worship, but the remainder of the church was in a ruinous condition for centuries after. When Phillimore visited it in Edwardian times, most of the church was still in ruins. This would change in the early 1970s, however: after a major restoration project, St. Mary's Church was completely rebuilt and is today a perfectly good parish church, said to be the longest in Scotland.

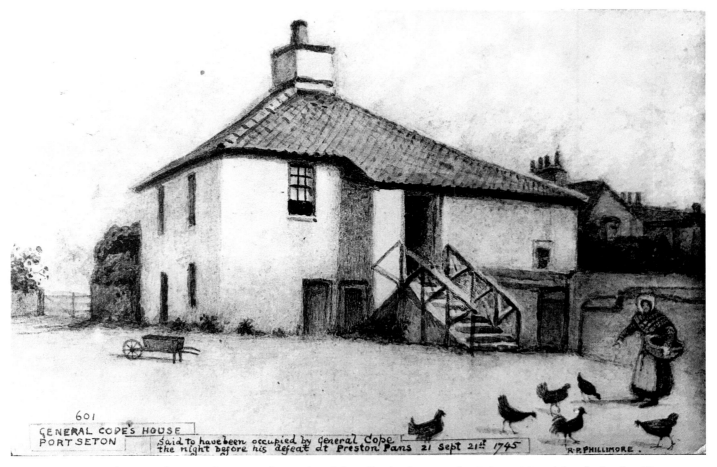

601

GENERAL COPE'S HOUSE
PORT SETON | Said to have been occupied by General Cope
the night before his defeat at Preston Pans 21 Sept 21st 1745

R.P. PHILLIMORE.

General Sir John Cope was in charge of the English troops who tried to defeat Charles Stuart in the 1745 uprising. After the battle of Prestonpans, in which many of his English troops fled for their lives when the Highlanders charged, he faced a court martial and his career was ended. Afterwards, there was a tradition that although Prince Charlie slept amongst his troops the night before the battle, Cope withdrew to comfortable quarters at Cockenzie, indicating perhaps cowardice on his part. In Edwardian times, Phillimore saw and depicted a house in nearby Port Seton that was pointed out as that inhabited by this ill-fated general. Later historians have tended to exonerate General Cope and disprove the calumnies spread about him by the victorious Scots. The legend of Cope's house in Port Seton remains obscure, however, and no such building stands today.

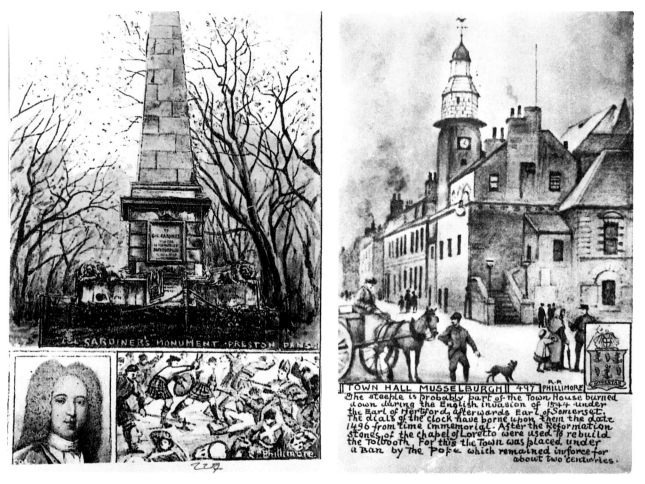

Within the images:

COL. GARDINER'S MONUMENT · PRESTON PANS

P. Phillimore

TOWN HALL MUSSELBURGH 497 PHILLIMORE

The steeple is probably part of the Town House burned down during the English invasion of 1544 under the Earl of Hertford, afterwards Earl of Somerset. The dials of the clock have borne upon them the date 1496 from time immemorial. After the Reformation stones of the chapel of Loretto were used to rebuild the Tolbooth. For this the Town was placed under a Ban by the Pope which remained in force for about two centuries.

One of the officers who came to grief in the Battle of Prestonpans was Colonel James Gardiner, who tried to rally some foot soldiers after his dragoons had fled the battlefield. The charging Highlanders knocked him off his horse, killed him and looted his possessions. Since Gardiner was a Scot, and because he was a brave officer who had fought to the end, a memorial obelisk was erected by public subscription in 1853, in the grounds of Bankton House where he had lived. The old town hall of Musselburgh dates back to around 1590, although it has been much altered over the years. Inside are the former burgh council chambers and community hall, as well as some police cells.

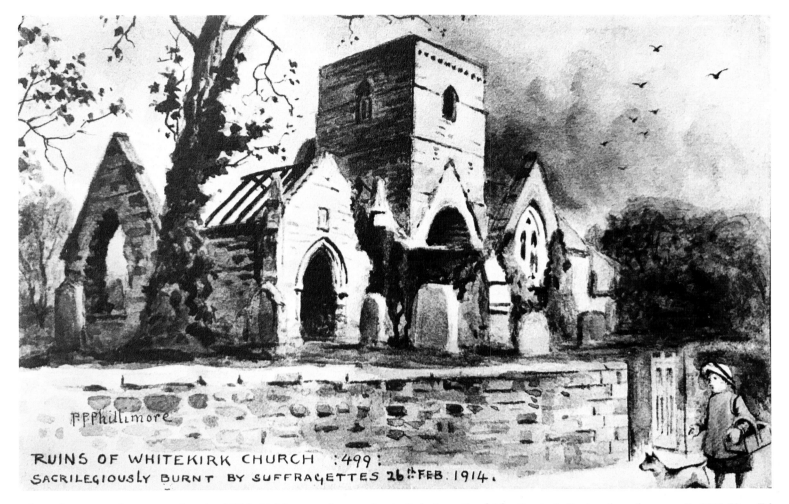

RUINS OF WHITEKIRK CHURCH :499:
SACRILEGIOUSLY BURNT BY SUFFRAGETTES 26th FEB. 1914.

P.P.Phillimore

About the 12th century, the ancient church of Whitekirk became famous due to its holy well, which attracted pilgrims from far away. In 1356, King Edward III of England plundered the church and took away the thanks-offerings left by the pilgrims. During the siege of Tantallon, Oliver Cromwell billeted his soldiers in the church, and stabled their horses there. In 1914, when Whitekirk was badly damaged by fire, it was suspected that suffragettes were involved, although this has never been proven. The church was repaired after the fire and has remained in good condition ever since.

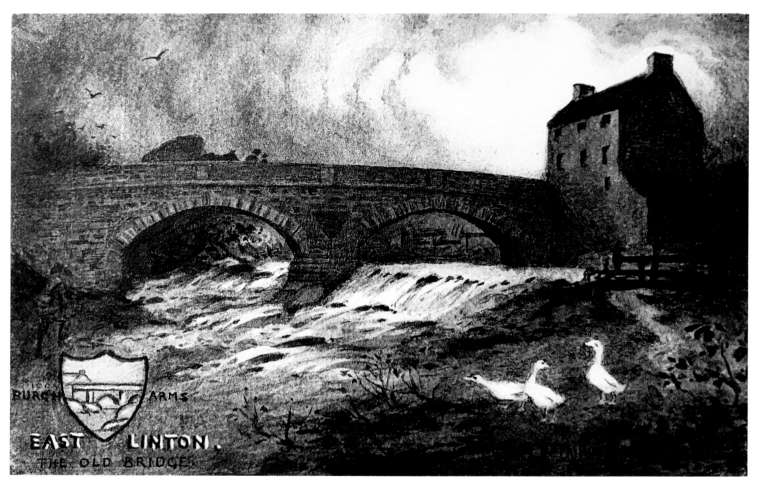

EAST LINTON.
THE OLD BRIDGE

This small town five miles east of Haddington is situated on the River Tyne, which is spanned by an ancient bridge, many times repaired and improved over the centuries. East Linton is served by Prestonkirk Parish Church, situated just outside the centre of town. Another attraction is Preston Mill, a working old watermill on the River Tyne in the care of the National Trust for Scotland. Although the main railway line passes right through East Linton, the station was closed down in 1964, an unhappy state of affairs for the locals, who have petitioned for the station to be reopened. Phillimore painted the East Linton bridge over the Tyne from the east, showing the bridge house, although the area where he set his easel is today private gardens.

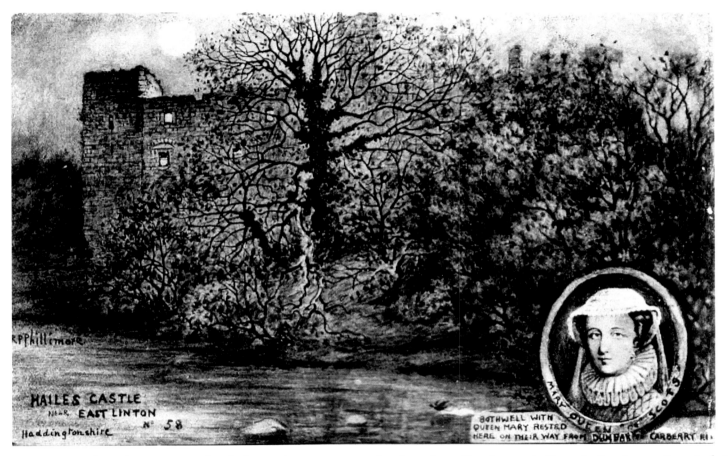

HAILES CASTLE
NeaR EAST LINTON
Haddingtonshire No 58

R P Phillimore

BOTHWELL WITH
QUEEN MARY RESTED
HERE ON THEIR WAY FROM DUMBAR TO CARBERRY HI

This castle dates back to the 13th century, as a fortified tower house constructed at the orders of local magnate Hugo de Gourlay, a mile and a half south-west of East Linton on narrow and winding country lanes. Because the de Gourlays supported the English in the War of Independence, Hailes Castle passed into the ownership of the Hepburn family. It successfully withstood a siege from Harry Hotspur Percy and his troops in 1400. The castle later came into the ownership of the Earl of Bothwell, who entertained Mary, Queen of Scots here in 1567, before the fugitive's nobleman's lands were forfeited to the Crown. Oliver Cromwell and his army came to call in 1650 after the Battle of Dunbar, destroying Hailes Castle with their customary thoroughness. The castle ruins were used as a granary in Victorian times but have since been taken over by Historic Environment Scotland, who have opened the site to visitors free of charge.

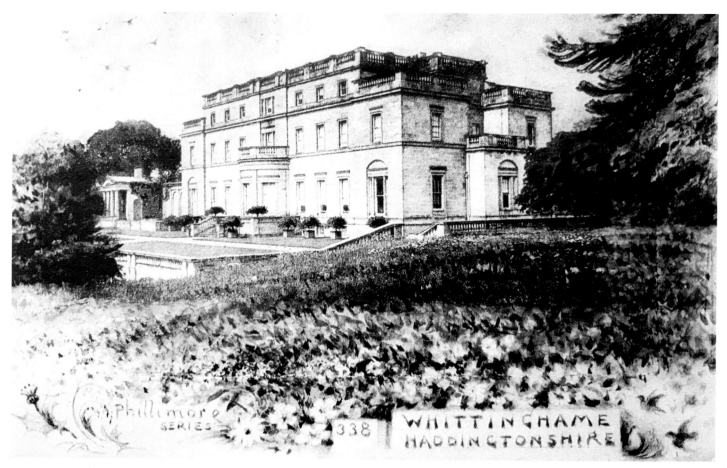

This grand neo-Classical mansion was constructed by Sir James Smirke in 1817, as the home of the wealthy Balfour family. Arthur Balfour, Conservative Prime Minister from 1902 until 1905, was born here. When King Edward VII came to visit him in 1908, he planted a commemorative oak tree in the grounds. Lord Balfour's nephew and heir opened the house as a school for refugee Jewish children in 1939. When the Balfours sold the house in 1963, it became the Holt School for Boys. The school closed in 1980 and Whittingehame House was sold into private hands. It looks reasonably well kept today, although its former grandeur has been spoilt by it being subdivided into flats. One of these flats, consisting of four bedrooms and some splendid reception rooms, came onto the market in 2017 for a cool £1.85 million.

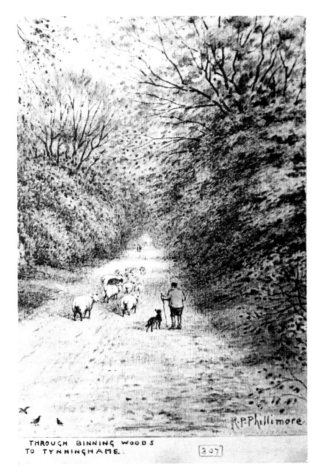

THROUGH BINNING WOODS
TO TYNNINGHAME.

[307]

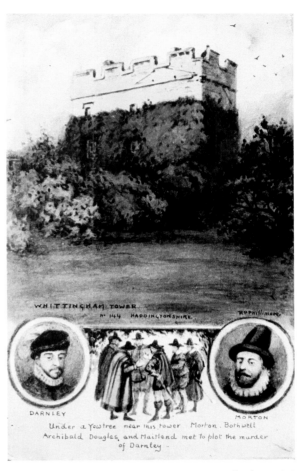

WHITTINGHAM TOWER
No 1464 HADDINGTONSHIRE

DARNLEY

MORTON

Under a Yewtree near this tower Morton, Bothwell
Archibald Douglas, and Maitland met to plot the murder
of Darnley.

Binning Wood near Tynninghame was planted at the orders of the Earl of Haddington in 1707. It was a mature wood when visited by Phillimore in Edwardian times, with a shepherd, sheepdog and sheep strolling through the unspoilt countryside. Much of Binning Wood was sawn down for the war effort, between 1942 until 1945, but it was replanted after the war. The Whittingehame Tower, a 15th century tower house in a rural setting, is said to have been the site where the Earl of Bothwell conspired with the tower's owner, Archibald Douglas, to murder Lord Darnley, although some historians claim the plot was hatched at Craigmillar Castle. The tower has survived wartime and strife, and although it looked rather ivy-covered and neglected when Phillimore came to call, it is today privately owned and well looked after.

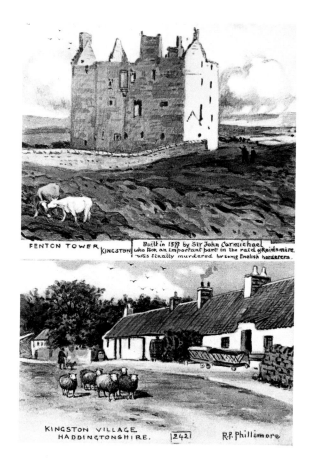

FENTON TOWER KINGSTON Built in 1577 by Sir John Carmichael who took an important part in the raid of Reidsmire - was finally murdered by some English borderers.

KINGSTON VILLAGE
HADDINGTONSHIRE. |242| R.P. Phillimore

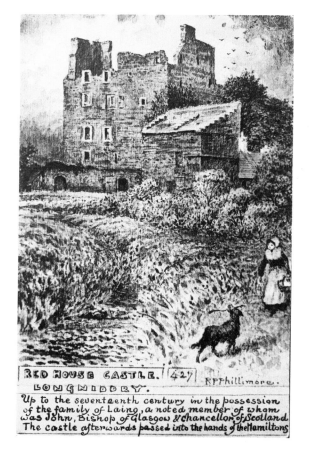

RED HOUSE CASTLE. |427| R.P.Phillimore.
LONGNIDDRY.
Up to the seventeenth century in the possession of the family of Laing, a noted member of whom was John, Bishop of Glasgow & Chancellor of Scotland The castle afterwards passed into the hands of the Hamiltons

The ancient Fenton Tower was sacked by Oliver Cromwell and his army in 1650, and remained in ruins when Phillimore was there in Edwardian times. Cromwell had done a less thorough job than usual, however, and much of the fabric of the tower remained intact. In 1998, it was decided to restore it under the supervision of Historic Scotland, and it is today a luxury hotel, with a commanding position over the tiny village of Kingston. Redhouse Castle, outside Longniddry, is a late 16th century tower house belonging first to the Douglas, then to the Layng and Hamilton families. After Colonel George Hamilton had been hanged, drawn and quartered for high treason, the castle stood empty for ten years before being bought in 1755 by Lord Elibank, who preferred to live in his Edinburgh town house. Redhouse Castle, today an imposing ruin with some curious pediments and carved stones, is in the grounds of Redhouse Nurseries.